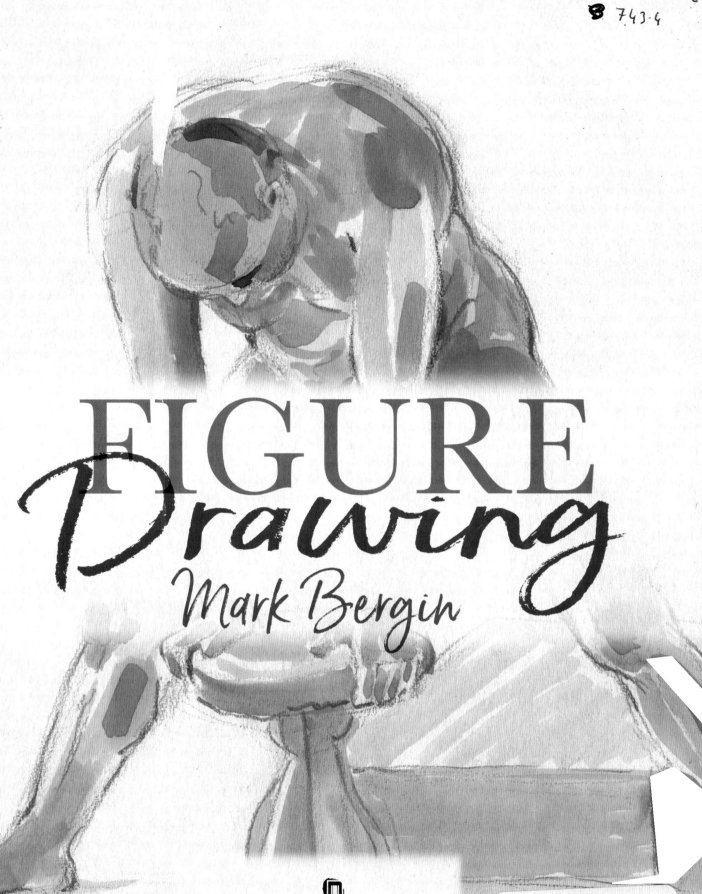

FIGURE
Drawing
Mark Bergin

BOOK HOUSE
a SALARIYA *imprint*

Published in Great Britain in MMXIX by
Book House, an imprint of
The Salariya Book Company Ltd
25 Marlborough Place, Brighton BN1 1UB
www.salariya.com

PB ISBN: 978-1-912233-99-1

SCRIBO BOOK HOUSE SCRIBBLERS

1 3 5 7 9 8 6 4 2

A CIP catalogue record for this book is available
from the British Library.

Printed and bound in China.

Additional Artists: Jermaine Elwood, Allison Marsden,
Nicole Rankin, Shirley Willis and Shutterstock.

Visit
www.salariya.com
for our online catalogue and
free fun stuff.

PAPER FROM
SUSTAINABLE
FORESTS

Contents

4 Introduction

6 Tools & materials

8 Making your mark

10 Anatomy (The skeleton)

12 Anatomy (The muscles)

14 Proportions

16 Heads & faces

18 Hands

20 Feet

22 Geometricising

24 Foreshortening

26 Perspective

28 Life drawing

30 Warming up

32 Chiaroscuro

34 Using photos

36 Sculptures

38 Negative space

40 Sketching

42 Charcoal (Sketches)

44 Charcoal (Expressive medium)

46 Using a brush

48 Light on dark

50 Soft pastel

52 Scratch pen

54 Strong colours

56 Watercolour (Techniques)

58 Watercolour (Tonal range)

60 Mixed media

62 Glossary

64 Index

Introduction
Looking and seeing

Learning to draw is about looking and seeing. Keep practising, use a sketchbook to make quick drawings and get to know your subject. Start by making very rough sketches to capture shape and movement. There are many ways to draw and this book shows only some of them. Don't forget that there are no right or wrong ways – just experiment with different methods and techniques that enable you to express yourself best. Above all, enjoy life drawing!

Length of pose

As you finish off a drawing, make a habit of jotting down how long you spent on it and the medium used. It's interesting to look back on previous work to chart how your skills have developed.

Experiment

Draw friends and family whenever possible as clothed figures make excellent models, too. It is also very useful to practise drawing yourself in the mirror. Try alternating the light source from above or below, then from opposite sides. Use every opportunity to experiment with unusual combinations of media to widen your scope.

4B pencil
(5 minute sketches)

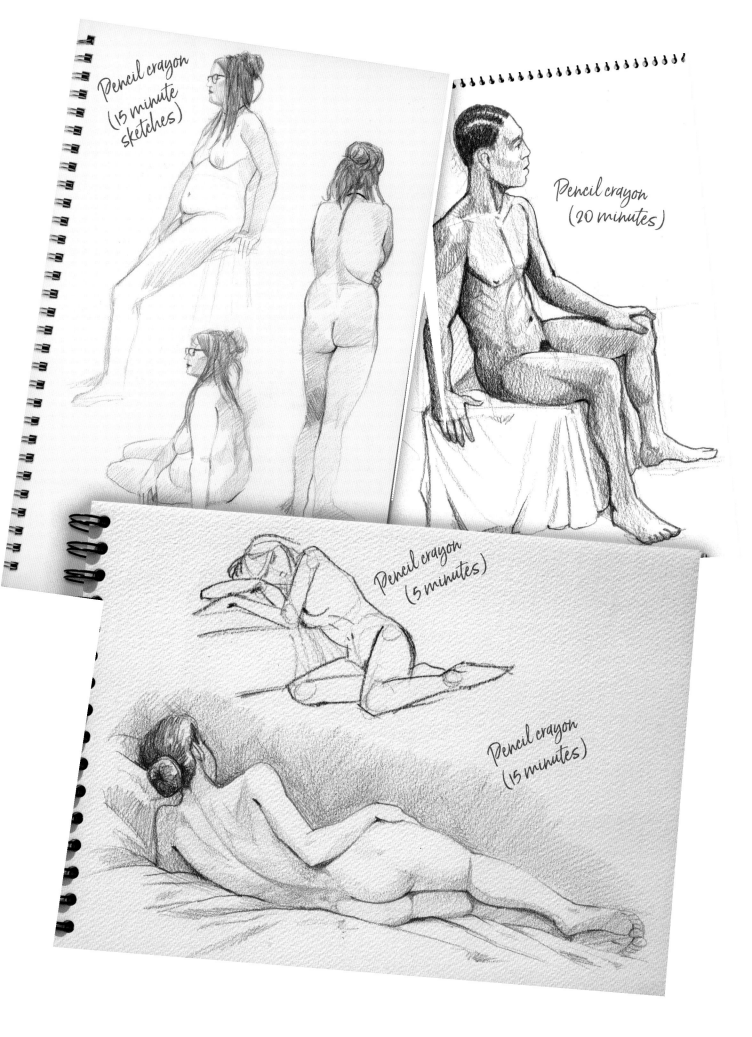

Pencil crayon (15 minute sketches)

Pencil crayon (20 minutes)

Pencil crayon (5 minutes)

Pencil crayon (15 minutes)

Tools and materials
Getting started

No special tools and materials are required for drawing nude figures. Use whatever you have to hand – any paper, something to rest it on and a pencil. That is all you really need to get started.

Putty erasers are good for erasing charcoal. It can be moulded into a point for erasing fine details.

Experiment

These are some of the tools and materials that have been used in this book. Experiment with art materials to find out which ones you most enjoy using.

Two drawing kits

It's a good idea to have two drawing kits; a very basic kit for drawing 'on the go', and a second one with a wider range of tools for working at home and life drawing classes.

Willow charcoal comes in sticks and makes dark, dense marks that can be erased. **Vine charcoal** comes in blocks and is harder than willow. **Compressed charcoal** makes hard, dense marks and is hard to erase.

Graphite pencils come in different grades, varying from hard to soft. They produce a wide range of shades, from grey to black.

Putty eraser

Charcoal

Graphite pe...

Soft pastels come in stick form. Using soft pastels to draw on coloured paper quickly produces exciting results, and creates unexpected colour combinations.

Cartridge paper comes in a range of thicknesses and textures. Smooth surfaces are best for detailed drawings. Use thick paper or watercolour paper when painting in watercolours.

Coloured paper or pastel paper is ideal for soft pastel drawings.

Spray-on fixative can be used to fix pastel and charcoal drawings. Note: read the manufacturer's instructions before use.

Coloured pencil crayons are ideal for subtle life drawings. Try layering darker colours on top of lighter ones to create shading and depth.

Watercolours produce subtle effects and come in tubes, blocks or bottles. Use a medium, pointed paintbrush and a limited colour palette to start with.

Indian ink comes as water-soluble or non-watersoluble. Whichever ink you use, it's always important to clean the nib directly after use.

Scratch pens consist of a nib and holder. These dip pens can create exciting and varied ink lines.

7

Making your mark

First marks

Mark making

The technique of using different lines and textures to create a piece of art is called mark-making. Inked dots made with a pen nib, soft lines created with charcoal and brush strokes of paint are all forms of mark-making.

Drawing lines

Drawing lines is a fundamental part of life drawing. Most artists start by producing wavery, hesitant lines. With practice their lines become more confident, powerful and descriptive.

Different marks

Marks can be used to describe the 3D quality of a shape and to suggest the texture of the image. Some marks can indicate movement while others may even express emotions.

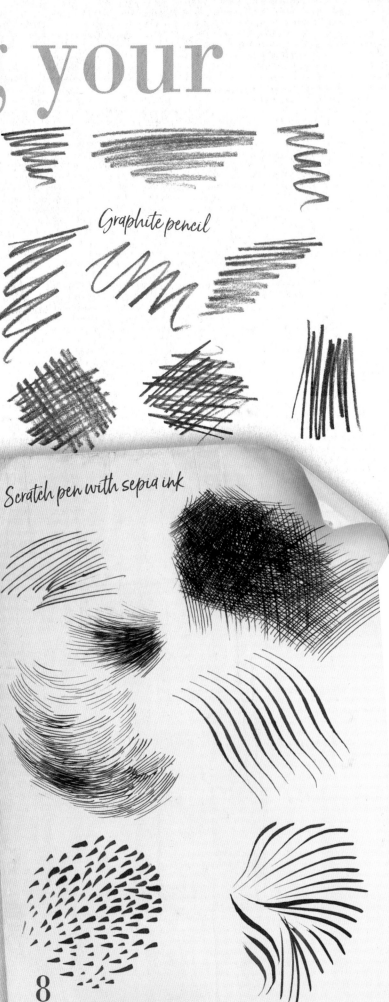

Graphite pencil

Scratch pen with sepia ink

8

Charcoal lines

Smudged charcoal

Lines created by using the side of a charcoal stick

Using either graphite pencil or charcoal, try alternating the pressure you apply at the start and the end of a line. Use the side of a stick of charcoal to create different marks. This technique is useful for blocking-in areas of shadow on a life drawing.

Black ink and a wide brush

Sponge and ink

Watercolour paint and different-sized brushes

Practise drawing lines using different tools and materials. These lines were drawn with a series of different-sized paint brushes. Try drawing straight, curved or wavy lines – just experiment!

9

Anatomy
The skeleton

What's inside

Understanding the basic internal structure of the human body – the skeletal and muscle systems – will help you to draw nude figures with more solidity and life.

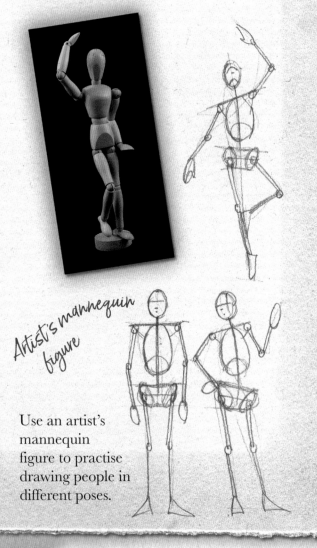

Artist's mannequin figure

Use an artist's mannequin figure to practise drawing people in different poses.

The underlying skeletal structure helps you to define the shape and form of your subject.

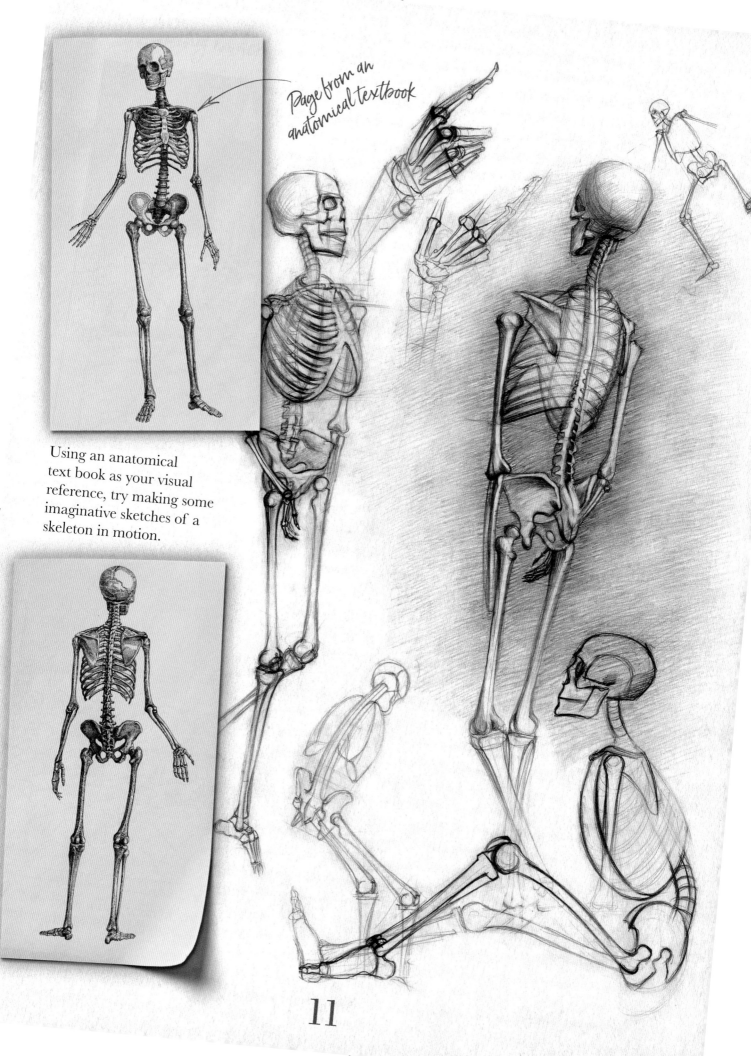

Using an anatomical
text book as your visual
reference, try making some
imaginative sketches of a
skeleton in motion.

Anatomy
The muscles

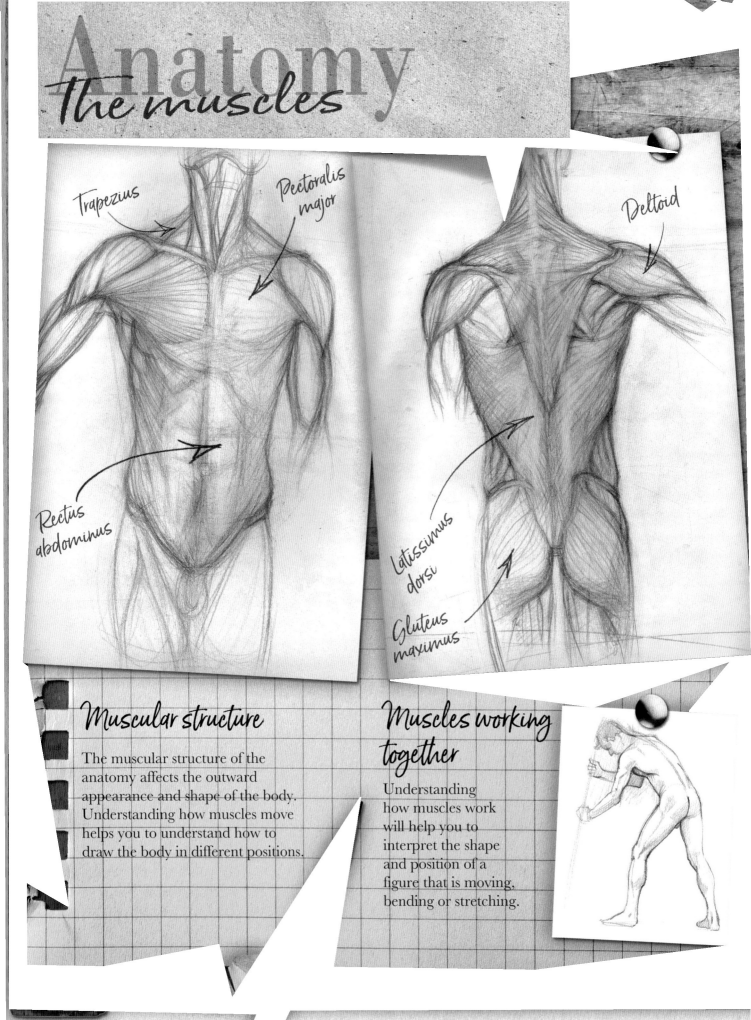

Trapezius

Pectoralis major

Deltoid

Rectus abdominus

Latissimus dorsi

Gluteus maximus

Muscular structure

The muscular structure of the anatomy affects the outward appearance and shape of the body. Understanding how muscles move helps you to understand how to draw the body in different positions.

Muscles working together

Understanding how muscles work will help you to interpret the shape and position of a figure that is moving, bending or stretching.

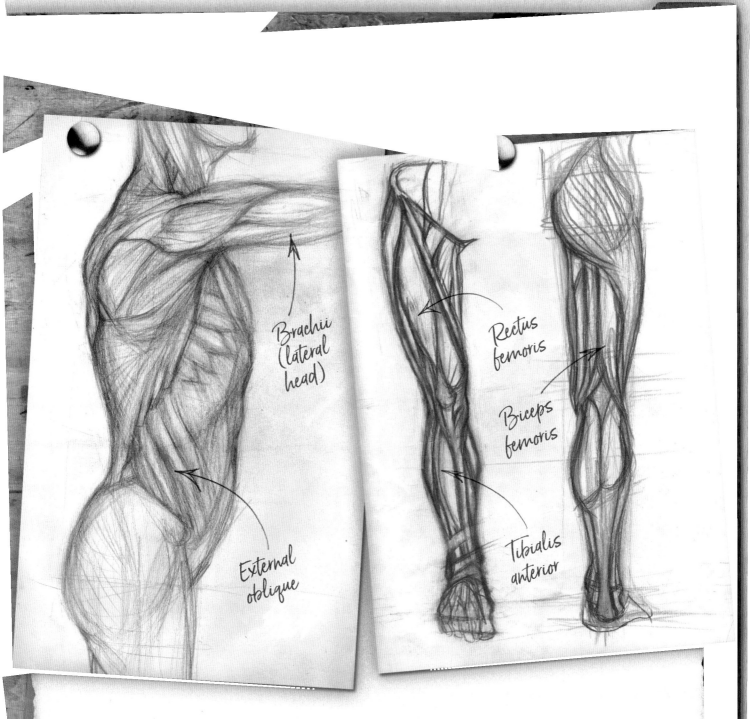

Brachii (lateral head)

External oblique

Rectus femoris

Biceps femoris

Tibialis anterior

How muscles move

1. A muscle pulls together the parts of the anatomy to which it is attached.

2. When a muscle is activated, it contracts, becomes hard and bulges. The harder the muscle works – the more pronounced the bulge.

3. An inactive muscle is relaxed, feels softer and does not bulge.

4. To revert to its original position a second muscle (called the antagonist) needs to pull in the opposite direction. Most muscles are paired, and when one is contracted, the other is relaxed.

Proportions
Measuring, comparing

To draw the standard proportions of a female figure the head should fit about seven times into the body length (see below). On average, men are taller so the head should fit eight times into the male body length (see p. 15).

The proportions of a female figure shown from different views

Close observation

There is so much variation in body types, that no proportional guide is correct for all subjects. However, it is useful to have a basic understanding of average proportions as described here. Remember that figure drawing relies on close observation.

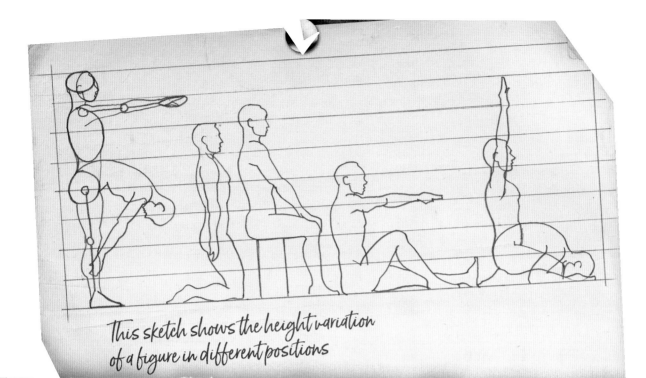

This sketch shows the height variation of a figure in different positions

The proportions of a male figure shown from different views

Use standard proportions to check the figure you are drawing. The kneecaps should start two head heights up from the ground, but measure and check how this relates to your model.

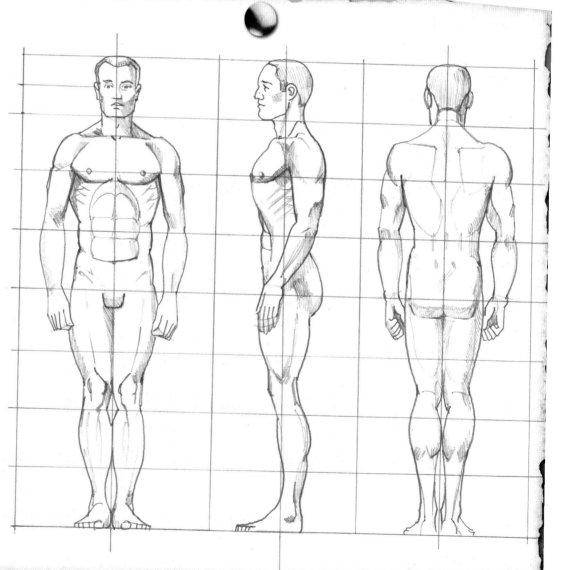

Expressive features

Heads can be difficult shapes to draw as the face includes some of the most expressive human features. Use construction lines to help place the eyes, nose, ears and mouth accurately on the head.

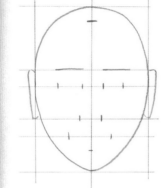

Mark the horizontal position and the widths of the eyes, nose, mouth and ears.

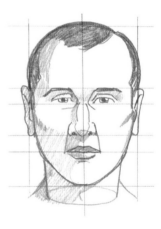

Now start to draw in the facial features. Pencil in the hair. Add some shading.

Frontal view

Start by drawing a simple oval for the head shape.

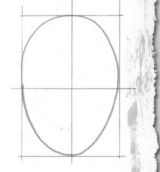

Squaring up the paper helps you to site the correct position of all facial features.

Side view

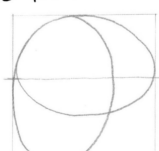

Draw in the main shape of the head by overlapping two ovals (as shown).

Add construction lines for the nose, eye and mouth. Draw in the facial features. Add hair.

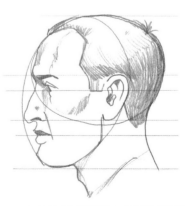

Tilted down... or up

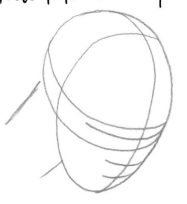

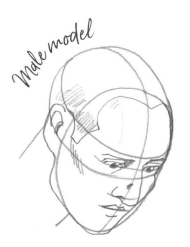

Male model

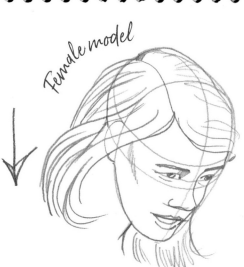

Female model

Draw curved construction lines (as shown) to place the facial features.

Draw in the features and the hairline. Carefully position the ear.

Note how the fall of the hair reflects the downward tilt of the head.

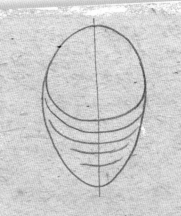

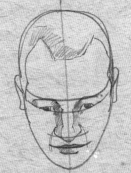

Curved construction lines help you to place the features accurately.

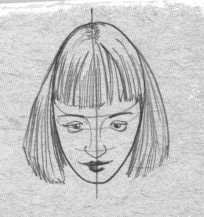

Downward curving construction lines show the head facing downwards.

Add detail and any extra features, such as hair.

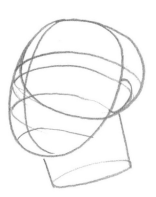

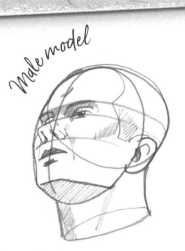

Male model

Female model

Construction lines curving upwards show the head facing up.

Draw in the features. Do not forget the underside of the chin.

Complete any details and remove unwanted construction lines.

Hands
Movement

Geometric shapes

Try to reduce the hand to a series of geometric shapes. Flat angular planes make up the wrist, palm and back of the hand. Use construction lines to indicate the direction and joints of the fingers and thumb.

Finger joints

Waving

Pointing

Gesturing

Holding a pencil

Grabbing

Draw your own hand

Practise, practise, practise! Your other hand isn't doing anything so draw it. Work on a range of studies from quick sketches to more finished drawings. Add shading to create a 3D effect.

HB pencil sketch

Studies of hands

Make quick sketches of other people's
hands. Try capturing them in action:
holding a cup, texting or writing
with a pen.

B pencil sketch

Note how the curved pencil lines in
this sketch accentuate the rounded
form of the fingers and hand.

Keep sketching – don't worry if
drawings are incomplete, carry
on until your paper is covered.

Charcoal study

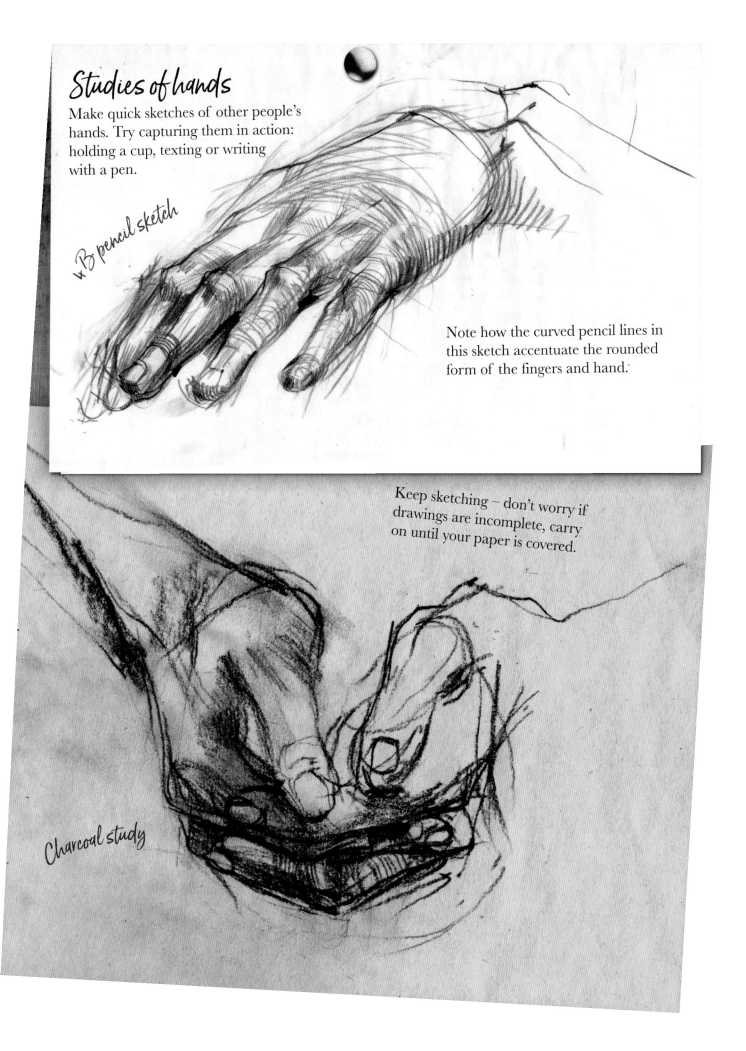

Feet
Weight and form

Geometric shapes

Feet can also be drawn as a series of geometric shapes. The main part of the foot is wedge-shaped. The heel forms a sphere and the toes a triangular shape. The weight of the body is carried directly below the ankle.

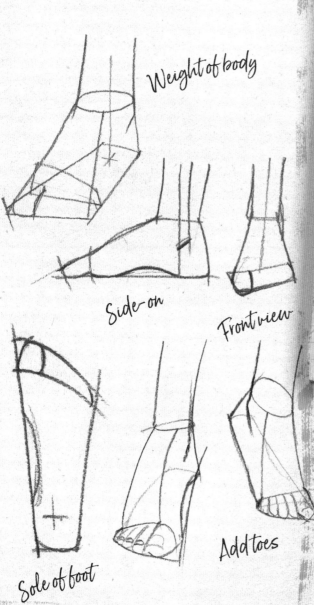

Weight of body

Side-on

Front view

Sole of foot

Add toes

Ballpoint pen

Draw your own feet

Do a series of sketches of your own feet. Draw them from different angles by placing a mirror at floor level so you see your feet from a variety of viewpoints. Loosely sketch in the basic shapes, then draw in the toes. Finish off all details and add shading to complete.

Practice

Feet are difficult shapes to draw so practise drawing them whenever you can. Use a variety of mediums and sketch them from all angles.

4B pencil

Pencil scribble (HB – 2B)

Keep sketching – do lots of simple studies to improve your drawing skills. As your confidence builds try some more detailed drawings of feet.

4B – 6B pencil

Geometricising
Using geometric shapes

Capturing the essence

Visualising the complex form of the human body in simple geometric shapes, such as spheres, cubes and cylinders is called geometricising. Reducing the human figure to its essence in this way helps make it easier to draw.

Inverted and upright triangles

Use an inverted triangle for the male torso and an upright triangle for the female torso. This is a quick and effective way to establish the different body shapes of men and women.

Use simple shapes: cylinders, spheres and cubes (as shown) to practise drawing human figures in different positions.

Width at shoulders

Male figure

Female figure

Width at hips

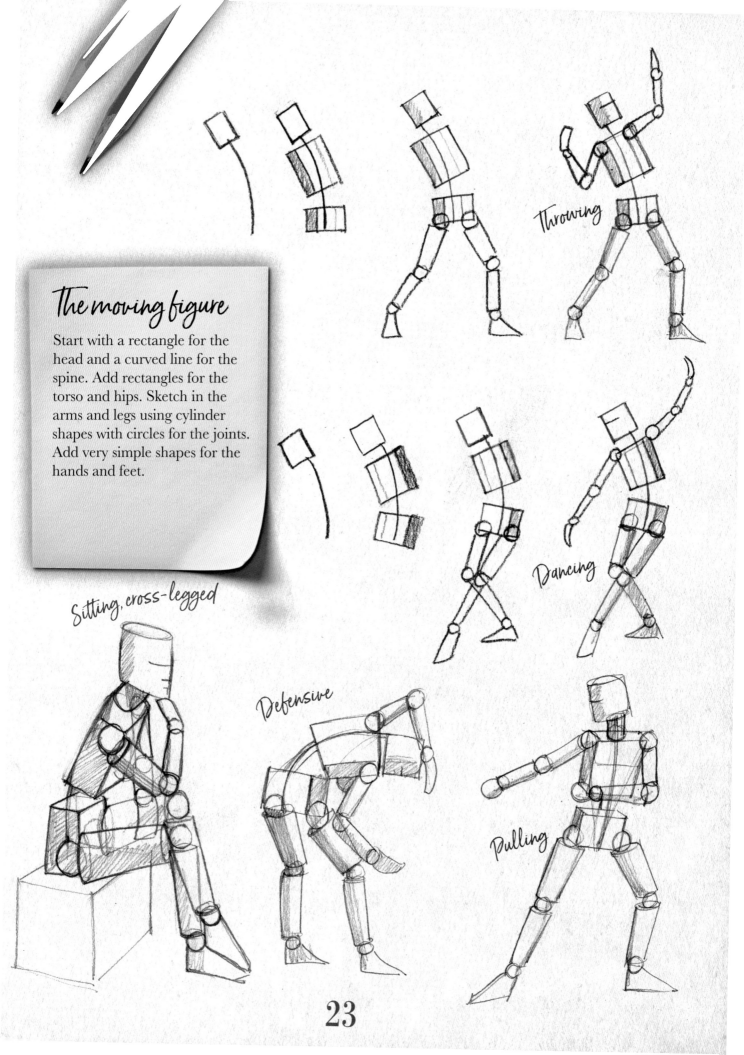

The moving figure

Start with a rectangle for the head and a curved line for the spine. Add rectangles for the torso and hips. Sketch in the arms and legs using cylinder shapes with circles for the joints. Add very simple shapes for the hands and feet.

Throwing

Dancing

Sitting, cross-legged

Defensive

Pulling

Foreshortening
Using simple shapes

Foreshortening is a drawing technique that creates the illusion of depth. Drawing part of your subject smaller than it really is makes it appear to recede from the viewer.

Shading

In this drawing of a reclining figure (below), the thighs have been foreshortened. Adding shading helps to clarify the relationship between the body and limbs. It also adds a sense of weight to the pose.

Shading foreshortened limbs emphasises their rounded form and further defines position.

Try to construct the body from simple shapes

Construct the body

In this pose (right), the exact point where the figure's legs join the body is hidden. However it is crucial to get this relationship right to draw the pose correctly. The figure must be constructed as though it were visible in its entirety in order to accurately relate the elevated angle of the legs to the body.

Construction lines will help you to correctly position and relate the foreshortened parts of the body to the limbs in the foreground.

Pastels on coloured paper (2 hours)

Perspective
Three dimensions

If you look at anything from different viewpoints, you will see that the part that is closest to you looks larger, and the part furthest away from you looks smaller. Drawing in perspective is a way of creating a feeling of space – of showing three dimensions on a flat surface.

One point perspective

(V.P.)

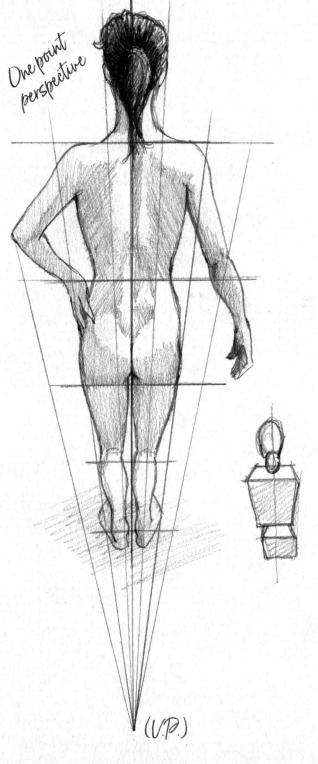

One point perspective

(V.P.)

One point perspective (see above and right), is used as a visual guide to make shapes smaller as they recede.

The vanishing point (V.P.) is the place in a perspective drawing where parallel lines appear to meet. The position of the vanishing point depends on the viewer's eye level.

Two point perspective

Two point perspective uses two vanishing points: one for lines running along the length of the subject, and one on the opposite side for lines running across the width of the subject.

(V.P.) (V.P.)

(V.P.) (V.P.)

(V.P.)

Three point perspective

Three point perspective drawings use three vanishing points. This method is good for drawing subjects from a high or low eye level.

27

Life drawing
Attending a class

Students attend life drawing classes to make observational drawings of a clothed or unclothed model. Life drawing is fundamentally a way of training your eye and hand to work together to create an accurate interpretation of the model's pose.

What to take:

Basic materials

• Sheets of paper or a sketchbook
• Range of graphite pencils
• Eraser
• Sharpener
• Drawing board

Additional choice of media

• Charcoal sticks
• Ballpoint pen
• Scratch pen and ink
• Coloured pencil crayons
• Soft pastels
• Conté crayons
• Paint brushes and inks
• Water pot
• Marker pens
• Variety of papers
• Putty rubber for erasing fine detail

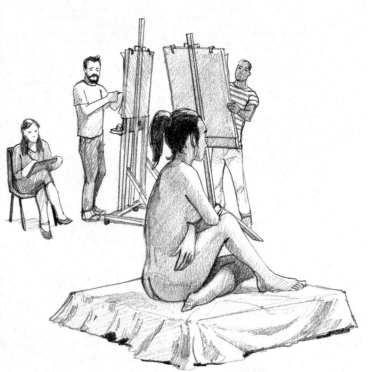

Decide which view you want to draw. You can choose to be seated with a drawing board or stand at an easel. Try both ways to see which you prefer.

Using an easel

Make sure you can draw and see the model at the same time to make direct comparisons as you work.

28

Measuring and aligning

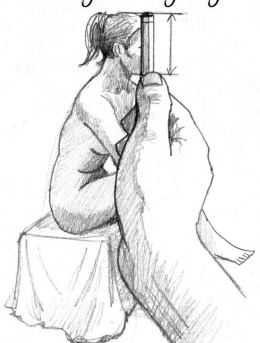

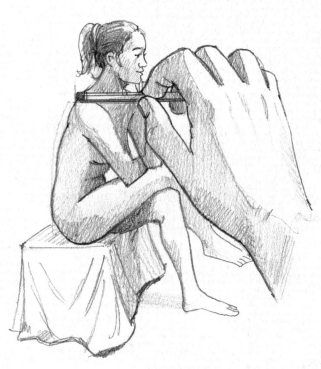

Repeat this measuring process by aligning the pencil with various parts of the model's anatomy to check your drawing proportions.

Vertical and horizontal lines

Study the model carefully. Close one eye and hold your pencil out at arm's length. Use your thumb to measure the head height and use it to gauge the length of other parts of the figure.

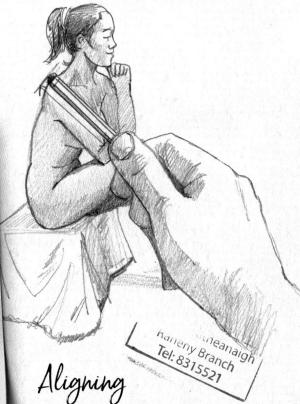

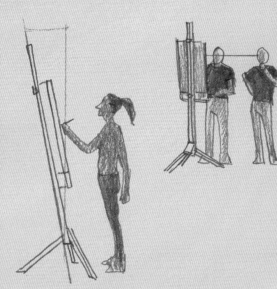

Adjust your easel to a comfortable angle. It is best to have space to step back to appraise your drawing.

Aligning

Close one eye and hold a brush or pencil at arm's length. Align it with various parts of the figure that lie on the same plane. If your drawing is going wrong this ongoing process of checking will quickly alert you.

Capture the pose

Life drawing, helpful tips:

1. Always take time to study the model. Look at the overall shape of the body, the line of the pose and the weight-bearing parts of the body.

2. Try to capture the essence of the pose and don't be distracted by details. Learn to see the drawing as a whole.

3. Drawing hands, feet and faces can be daunting – but don't be put off. Have a go.

4. The more you draw the more fun it will become. Don't set out to draw a photographic representation of the model. Experiment by working in a range of techniques and develop your own unique style.

5. Making mistakes is part of the drawing process. You will soon learn when to correct mistakes and when to abandon and start again.

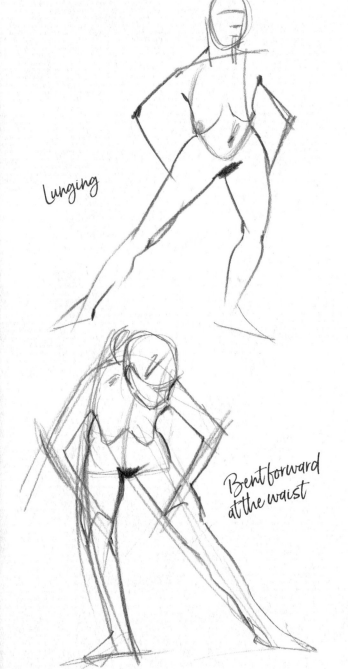

Lunging

Bent forward at the waist

Quick sketches

Making quick 1-3 minute sketches of nude figures in different poses is a good warm-up exercise. It requires quick observation and mark-making which launches you straight into 'drawing mode'. It hones your understanding of how a body completely changes shape as it moves.

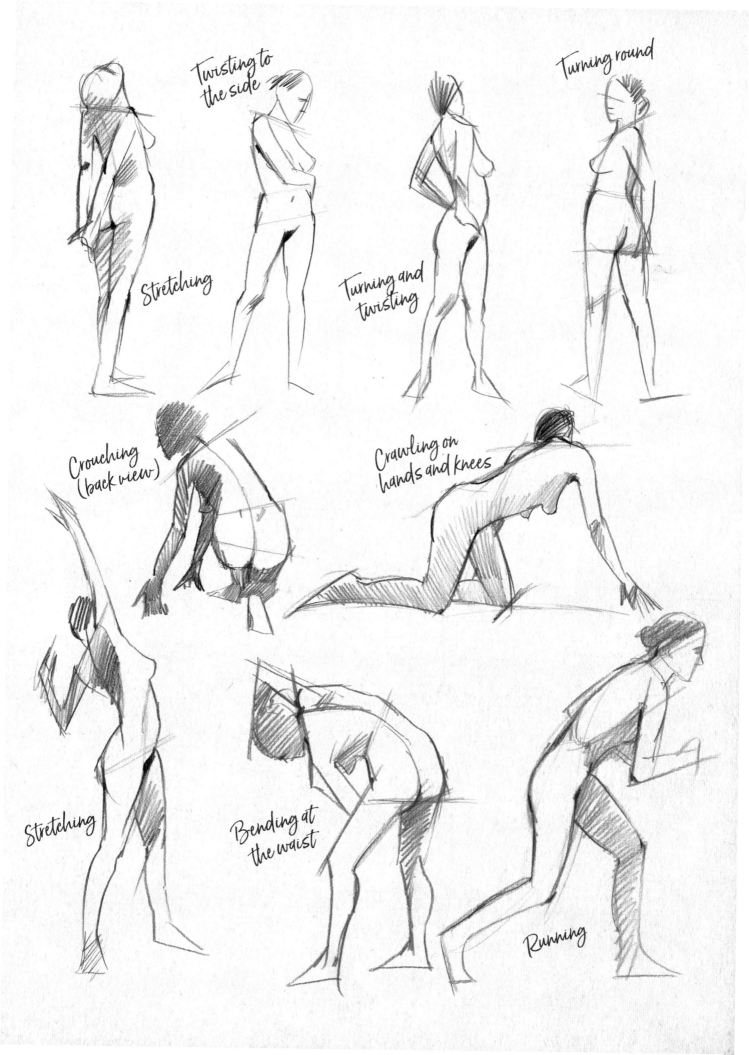

Twisting to
the side

Turning round

Stretching

Turning and
twisting

Crouching
(back view)

Crawling on
hands and knees

Stretching

Bending at
the waist

Running

Chiaroscuro
Light and shade

Chiaroscuro is an Italian term which literally means 'light-dark'. It refers to the use of strong tonal variations between light and shade in any artwork. It is used to show the modelling and form of the subject.

Light source

There are several aspects of light that must be considered in any drawing of a nude figure. The direction of the light source is crucial but be aware too of the quality of light and the shadows created by it.

Three dimensions

Adding shading to specific areas of a life drawing gives an appearance of depth and can produce a sense of three dimensions. Shading can also be used to make parts of an image blend into the background.

Hatching using a pen

Cross-hatching using a pen

Pencil techniques: Hatching

Hatching builds up tone using a series of thin parallel lines. Lines drawn closer together create darker tones.

Cross-hatching

Cross-hatching is when a second set of parallel lines criss-crosses the first. Add more sets of lines to create even darker tones.

Smudging

Smudging is a useful technique for blending graphite pencil shading. Simply use the tip of your finger to smudge the pencil lines.

Scribbling

Use scribbling for shading various textures. To create dark tones simply make your scribbling denser.

Two light sources

Before adding shading to a life drawing first establish the direction of the light source. In this instance the main light source is from the front and to the left of the figure. A secondary light source is illuminating the model from the front and right hand side.

This drawing (left) was executed on a pale brown, mid-tone paper. Pencil crayons were used to convey the warm and cold hues of the body. Finally highlights were added using a white conté crayon.

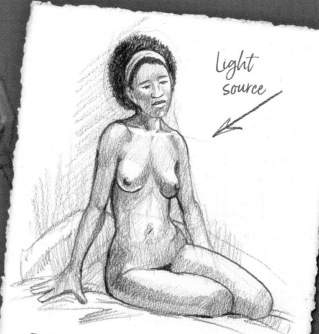

Light source

Build up layers of shading gradually. Think of the body structure and use shading to define muscles and to create the rounded shapes of a body.

Pencil crayon and conté crayon (1 hour 50 minutes)

Tip: Is your shading effective? Look at the model and then at your drawing through partially closed eyes.

Practice and more practice

Drawing from life is always preferable to drawing from photographs. It is very difficult to make a drawing from a photograph look as interesting as one made from life. A photograph is a flat, two-dimensional image of something that is solid and three-dimensional.

Using photos

However, drawing different poses from photographs can still be great practice.

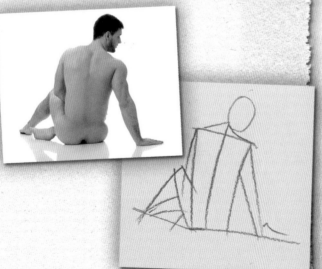

1. Start with a loose, sketchy drawing of the figure. Use simple shapes and lines to capture the position and pose.

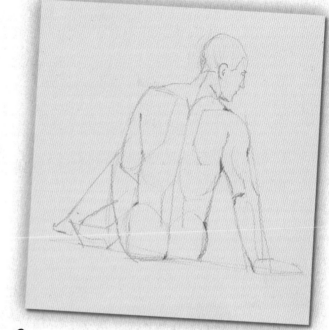

2. Draw in the outline of the figure. Now think about the underlying anatomy and muscles and how they define the shape of the body. Sketch in the hair and facial features.

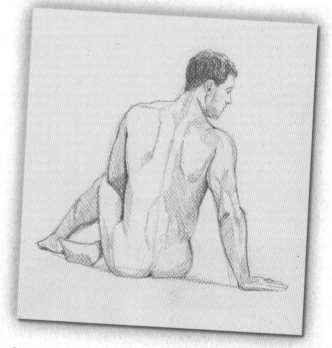

3. Add shading to define the texture of the hair and stubble, and to show parts of the body that are in shadow.

34

Shading technique

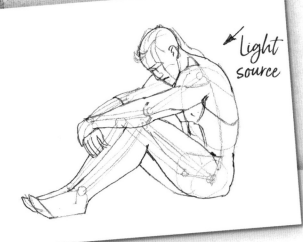

When shading, you must take into account the direction of the light source. Consider the pose, the body shape and musculature. Cast shadows are also very important.

An artist's mannequin (p. 10) may help you to correct the proportions and position of the pose you are drawing.

Start drawing in the body shape. Use the body's visible 'landmarks' – those parts of the underlying bone structure that create the outward shape.

Light source

Light is coming from the right-hand side so most of the shading and shadows are on the left-hand side of this subject. Use a wide tonal range. The darkest areas are where light does not reach. Add shadows under the figure to ground it, and a strong shadow cast on the wall.

Light source

Study the human form

A rt gallery and museum collections of statues and sculptures are treasure troves for figure drawing. Many municipal gardens and stately homes contain figurative sculptures, too. These sources will provide you with great opportunities to study the human form.

Pale marble

Drawing statues has advantages: the model doesn't move and the lighting is consistent. If possible, choose a statue carved in pale marble and it will show up the nuances of light and shade more clearly.

Similar challenges

Drawing a three-dimensional sculpture is more demanding than working from photographic references. A statue presents similar challenges to drawing from life, as you have to translate a complex, solid shape which has depth and perspective onto a flat sheet of paper.

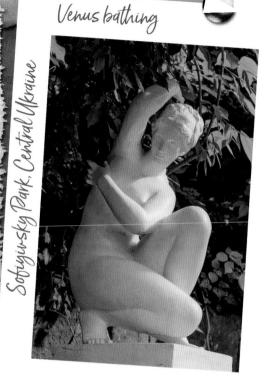

Venus bathing

Sofiyivsky Park, Central Ukraine

Detail of Laocoön and His Sons statue
Vatican Museum, Rome, Italy

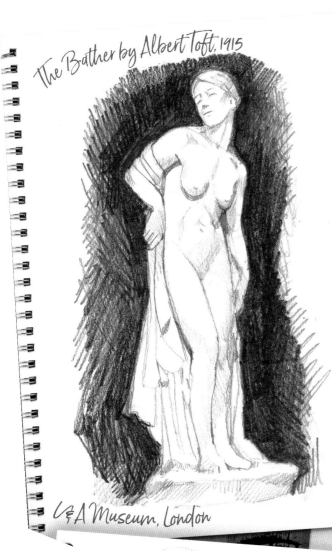

The Bather by Albert Toft, 1915

V&A Museum, London

Take minimum equipment – simply a
sketchbook, pencil, eraser and sharpener...
and something to hold pencil shavings.
A fold-up stool might also be handy.

Ancient Roman statue,
Vaison-la-Romai
France

Life and vigour

Before you start drawing, take time
to study the statue. You can make
a straight figurative study. You may
also use it simply as a reference,
incorporating the statue's pose and
shape into a figurative drawing of
your own creation.

Improve your skills

When drawing a figure we are inevitably influenced by how we expect the body to look. To improve your figure drawing skills it's useful to develop the ability to see your subject without any preconceptions. Try drawing the abstract or 'negative' spaces around a figure in order to create a silhouette of your subject.

A handy tool

Awareness of negative space is a vital tool when life-drawing. If the negative spaces are not correct then your drawing will also be wrong. As you draw, constantly check that your subject and the negative space around it correspond accurately.

Keep switching

To make sure that the proportions of your figure drawing are correct keep switching between drawing detail and drawing the entire figure.

1. Study your subject, paying special attention to the spaces inbetween the whole body mass.

2. Draw in the negative space surrounding the figure. Add the shape of any furniture or props used by the model.

38

This life study began as a drawing of
negative space. In order to make the figure
stand out the negative spaces were lightly
shaded using an umber coloured crayon.

Sketching
On the go

Don't forget...

Always carry a sketchbook and basic drawing materials with you so you can make sketches whenever the opportunity arises. Don't be put off by passersby watching as you draw – if you feel shy, try to go sketching with a friend.

Where to draw

It's best to start by drawing people who aren't on the move. Coffee shops and cafés, shopping malls, parks, queues and public transport are all excellent sources for a variety of subjects to draw.

How to draw

Look for someone who isn't moving about and isn't aware of being drawn. They may not remain in that position long, so work quickly and try to capture the essence of the pose.

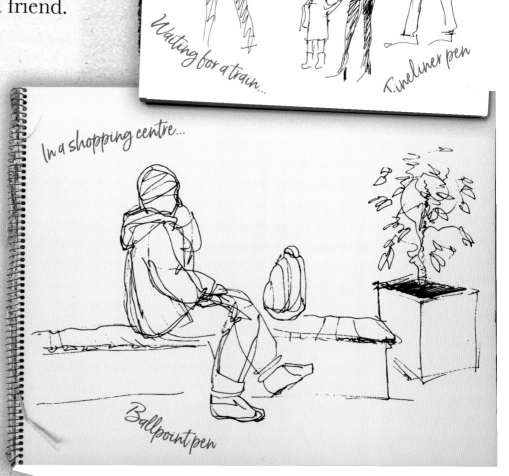

Waiting for a train...

Fineliner pen

In a shopping centre...

Ballpoint pen

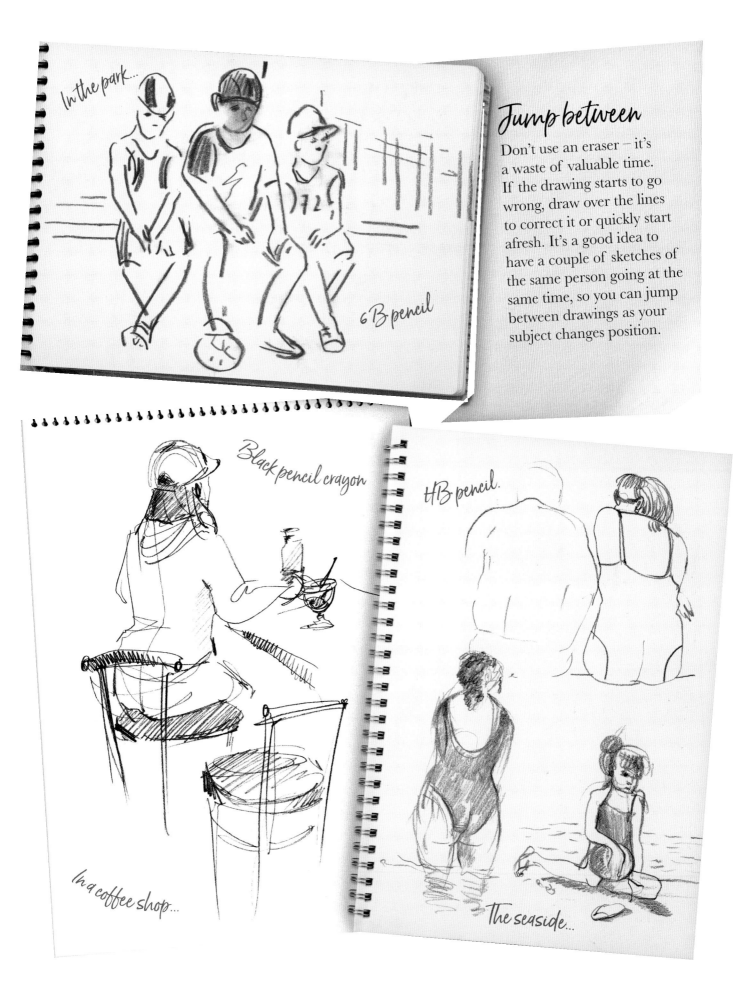

In the park...

6B pencil

Jump between

Don't use an eraser – it's
a waste of valuable time.
If the drawing starts to go
wrong, draw over the lines
to correct it or quickly start
afresh. It's a good idea to
have a couple of sketches of
the same person going at the
same time, so you can jump
between drawings as your
subject changes position.

Black pencil crayon

HB pencil.

In a coffee shop...

The seaside...

Charcoal
Sketches

Charcoal stick
(5 minute sketch)

Charcoal stick

This five-minute sketch (left) was done with a vine charcoal stick. The side of the stick is used to add grey shading.

Dynamic quality

The messy nature of a charcoal line makes it a lively medium for capturing the 'moment' in a figurative pose.

How to use charcoal

Drawing with charcoal is different from drawing with a pencil. Before starting on a charcoal life drawing practise making marks with it, as well as smudging and erasing. Try holding a charcoal stick in different ways until you feel comfortable drawing with it.

Compressed charcoal (5 minute sketch)

Compressed charcoal produces a darker mark than vine charcoal, and is harder to erase and smudge.

Charcoal
Expressive medium

Fresh and lively

Charcoal, like a pencil, is used for drawing, shading and blending. However, charcoal is a much more expressive medium. The very nature of charcoal forces you to work larger and bolder without getting stuck in detail. Try working with charcoal sticks; their blunt ends will help you to focus on the essence of the pose by using bold, sweeping lines to capture the largest shapes.

Putty eraser

A putty eraser is an extremely useful tool for creating highlights and for adding detail when drawing in charcoal. Putty erasers absorb the charcoal and become dirtier as they are used. It is possible to stretch and mould it into different shapes and to expose cleaner parts of the eraser. It can be formed into a point for precision work. Putty erasers also work well with graphite, pastel and chalk drawings.

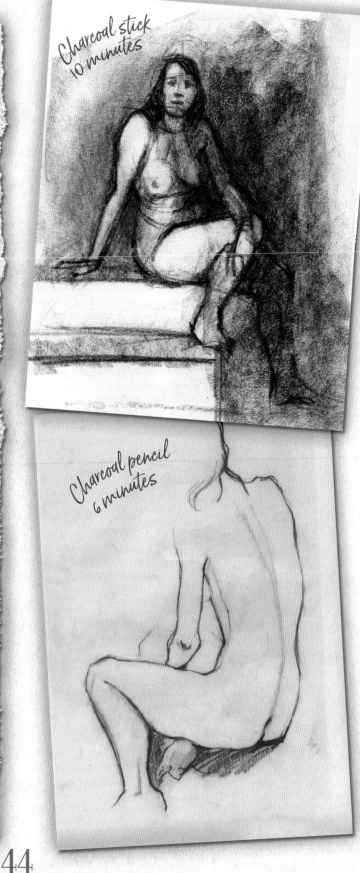

Charcoal stick 10 minutes

Charcoal pencil 6 minutes

Off the edge

If your drawing goes off the edge of the paper try to let it trail off. The viewer's eye will automatically focus on the main image.

Charcoal
1 hour

This study was first drawn using a charcoal line, then smudged charcoal was added to create various tones. Charcoal hatching and contour shading were used to enhance the 3D quality of the subject.

Fresh and lively

Most inks are waterproof and those that are dye-based stain the paper. So once you have made your mark there is no going back. If you make a mistake, don't worry and simply carry on. Ink is a very exciting medium to use. Ink lines and washes have tremendous freshness and liveliness.

Materials

It is best to use round, pointed watercolour sable brushes but any will do. These drawings were all made on thick cartridge paper, using a medium paintbrush and sepia ink.

Be prepared

Keep water on hand for rinsing brushes, and a small saucer or palette for diluting the ink. Use paper towels for drying brushes and blotting any excess ink.

(3 minute sketch)

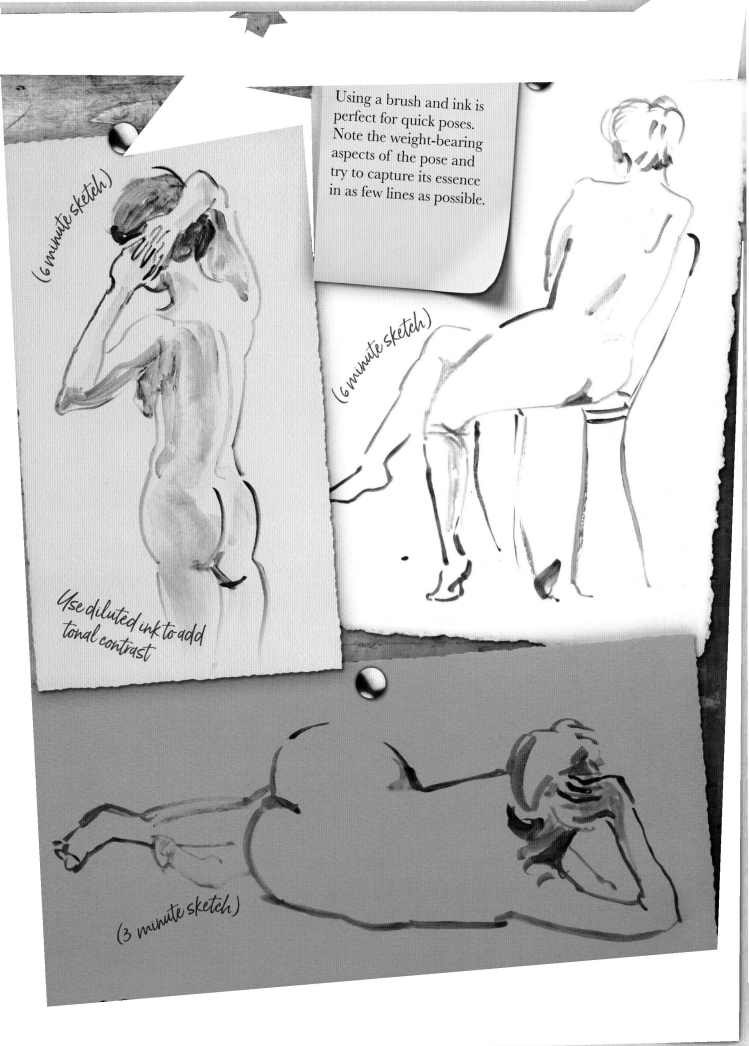

(6 minute sketch)

Using a brush and ink is perfect for quick poses. Note the weight-bearing aspects of the pose and try to capture its essence in as few lines as possible.

(6 minute sketch)

Use diluted ink to add tonal contrast

(3 minute sketch)

Pastel and Conté crayon

...or dark on light

These three drawings were executed on mid-tone coloured paper. Most artists work from dark to light – they sketch in the figure, draw the darker mid-tones, add areas of shadow and then draw in highlights as the finishing touches. However, some artists prefer to draw in the highlights first, and then build up layers of tone. See which way suits you best.

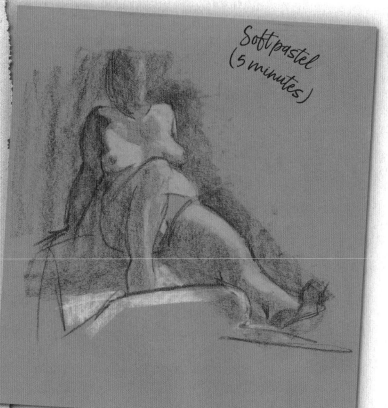

Soft pastel (5 minutes)

This life drawing (above) was sketched entirely in soft pastels. Highlights were added last.

Conté crayon (45 minutes)

Conté crayon

Conté crayon sticks are thinner and harder than soft pastels. They are ideal for more detailed life drawings as in this study. Conté crayons come in both stick and pencil form.

In this study, conté crayons were used for the initial life drawing as the colours mix well with soft pastel. Use rough-textured paper when working with conté crayons as it holds the pigment better than smooth paper. Study the figure carefully through partially closed eyes before adding the last touches of white and pale-coloured soft pastel highlights.

Conté crayon with soft pastel
(45 minutes)

49

Soft pastel
Large scale

Blending technique

There are many different ways to use soft pastels but the length of the pose often dictates the technique you use. You will almost certainly find it best to work on a larger scale. The reclining figure (below) was initially drawn with a coloured pencil crayon. The main areas of the drawing were then blocked-in with soft pastels and blended using a finger tip. Areas of dark tone and all highlights were added as finishing touches.

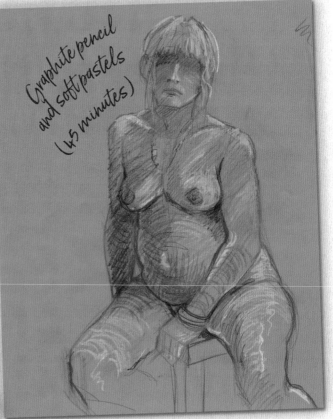

Graphite pencil and soft pastels (45 minutes)

If you intend the main background of the composition to be left plain, try working on a neutral to mid-tone paper (as above).

Soft pastels and coloured crayons (2 hours)

Soft pastels
(45 minutes)

Scratch pen
Spontaneous sketches

Transformation

A wide range of different types of pens are available for pen and ink drawing. Traditional, scratch or dip pens consist of a shaft with interchangeable nibs. The pen nib needs to be regularly dipped into the ink bottle to charge it with ink. Different shaped nibs produce a variety of line widths and marks.

Practise using scratch pens

Each nib produces exciting, variable lines which alter according to how much pressure is used. The ink also varies in density as it is applied. It is best to draw the pen across the paper towards you because pushing it forwards often creates ink splatters. Practise drawing lines, and try hatching and cross-hatching to build up tones.

Keeping clean

Keep water on hand to clean your nibs after use as dried ink is difficult to remove. Use paper towels to wipe and dry off the nibs and to blot off any excess ink.

Experimental lines

Blue-black ink

Hatching

Cross-hatching

Varied pressure

Contour shading

Pen and ink
(30 minutes)

Pen and ink drawings are spontaneous. If and when you go wrong simply correct any lines and carry on drawing – it will add an element of immediacy to the sense of 'work in progress'.

Ink and paper

Wide-based ink bottles are ideal as they are less likely to get knocked over. Try using Indian ink, and experiment with different coloured inks, too. Black, blue-black and sepia inks look particularly effective. Fine pen nibs tend to be scratchy on rough textured papers so smooth paper is best.

Pen and ink
(30 minutes)

53

Contrast and clash

Transformation

Adding colour creates a powerful emotional response that can transform a drawing. Colour can also be used to highlight parts of a drawing to make areas stand out. Warm colours (see below) can bring part of an image to the forefront while cool colours tend to make areas recede.

Colour temperatures

Reds, oranges and yellows are warm colours associated with fire and earth. They reflect feelings of happiness, energy, passion and enthusiasm.

Warm colours

Greens, blues and purples are cool colours associated with air and water. They reflect tranquillity, calmness and order.

Cool colours

Soft pastels (6 minutes)

Colours that clash

Certain colours placed side by side in a drawing create vibrant, clashing colour schemes. Examples of these include red and green, orange and blue, and purple and yellow.

54

Pencil crayons
(30 mins)

Developing skills

Experiment with different colour combinations to find out what does or doesn't work! Making errors is part of the process of developing your skills. This is especially relevant when you are working with coloured pastels, pencil crayons, inks or watercolours – none of which can be erased.

Pastels
(20 minutes)

Watercolour
Techniques

There are many different approaches to working in watercolour. For example you can use a paintbrush loaded with watercolour paint to draw directly onto dry paper. Alternatively, if you wet the paper surface first, the paint you apply will bleed and create exciting and random effects.

These figure studies were drawn with a 2B pencil on heavyweight cartridge paper. Diluted watercolour washes were then used to add tonal contrast and shadows.

4B pencil and watercolour (45 minutes)

You will need:

Keep water on hand to rinse your brushes and a saucer or palette to mix and dilute watercolours. It is easier if you have different sized brushes to add detail and to apply washes. Use paper towels for drying off brushes and to blot off any excess paint.

Add finishing touches to the drawing once the paint has dried. A brown felt-tip pen was used to define a few key elements on this drawing (above) once the paint had dried.

Limited palette

It's best to begin by using a limited colour palette. The time constraints on a life drawing limit your scope for elaborate colour-mixing processes.

Using a large paintbrush, apply the palest washes first. Build up the tone by adding layers of darker washes. Let the watercolour paint bleed. Remember to keep glancing between the model and your drawing to check that you have the right tonal values. Work quickly and don't worry if you have gone wrong – embrace your mistakes!

4B pencil and watercolour (30 minutes)

57

Watercolour
Tonal range

You can achieve an endless range of tones and effects with watercolours to produce lively, spontaneous life drawings that can be both subtle and dramatic.

3B pencil and watercolour (30 minutes)

Large scale

Try working on a larger scale. Tape watercolour or cartridge paper to your drawing board or to a wall if it's really large. Loosely sketch in the pose. Study the way the light falls on the figure before you start to block-in the main areas of shade with a large paintbrush. Build up the tonal values by adding layers of watercolour washes.

4B pencil and watercolour (36 minutes)

Watercolour and paper

Practise using bold and fine, delicate brush strokes, and try out different types of watercolour paper to work on. Fine-grained paper is ideal for small, detailed studies and coarse-grained creates wonderful, textured effects.

This study was drawn in soft graphite pencil. A large brush was used to block-in the figure with a pale watercolour wash. Before the paint was completely dry layers of darker watercolour were added. A black watercolour wash was used to block-in the hair and to add areas of darker shade.

When working on a larger scale it is important to keep stepping back to assess each stage of your drawing.

3B pencil and watercolour (20 minutes)

Mixed media
Experimentation

Watercolour and charcoal

Experiment by mixing watercolour with other media. Use a brush to loosely draw in a watercolour figure, and while the paint is still wet draw onto it with a charcoal pencil. The wet paint will concentrate the charcoal lines to create intense, deep blacks.

Try drawing in black ink using the point or side of a stick. When the ink is dry, add a bold stroke of a wide paint brush to create a base colour.

Auguste Rodin

Get inspiration by studying the work of other artists. Auguste Rodin, for example, often drew without taking his eyes off the model. He produced wonderful, spontaneous drawings using sweeping, curved lines. Try this yourself, study the model and start drawing without looking at the paper. Be adventurous, have fun and just see what works. Experimenting is a great source of inspiration.

Charcoal on watercolour

Black ink and

This lively life study was drawn in charcoal pencil, then watercolour was applied. Highlights were painted on using pale gouache, and lastly soft pastels were used to highlight a few key areas.

Glossary

3D solid rather than flat, with the dimensions of height, width and depth.

Anatomy the proportions and the skeletal, muscular and surface structure of the human body.

Artist's mannequin an articulated doll or dummy used as reference by artists.

Auguste Rodin a French sculptor and prolific draughtsman (1840–1917).

Bleed the visual effect achieved when a wash of dark colour seeps and merges into a lighter tone.

Blocking-in filling in large areas with solid colour.

Body proportions the relative size of different parts of a human figure within the whole body framework.

Chalk pastels are made by mixing together dry pigment, some chalk and a binder to form into a thick paste. The paste is made into sticks and dried.

Chiaroscuro an artistic technique used to represent light and shade in order to define three-dimensional objects.

Construction lines guidelines used in the early stages of a drawing; they may be erased later.

Conté crayon a drawing medium made from pigment and graphite. They come as rectangular sticks or as pencils and are usually coloured red, black, brown or white.

Cool colours greens, blues and purples, they are associated with air and water.

Cross-hatching the use of criss-crossed lines to indicate grades of denser shading in a drawing.

Fixative spray a type of resin used to spray over a finished drawing to prevent smudging.

Foreshortening a technique used for drawing perspective, it creates the illusion of an object receding into the distance or background.

Geometricising a process of rendering the complex form of the human body in simple geometric shapes.

Hatching a shading technique using a varied series of parallel lines.

Light source the direction from which light falls on a subject.

Mark-making different lines, patterns and textures used to create a piece of art.

Mixed media a technique using two or more artistic media.

Negative space the empty spaces between the component parts of a drawing. Accuracy is equally important in these areas.

Perspective a method of drawing in which closer parts of a subject are shown larger than those furthest away to give the impression of depth.

Pose a fixed position assumed by a life drawing model.

Proportion the correct relationship of scale between each part of a drawing.

Scratch pen consists of a metal nib and holder. These pens have to be dipped into ink to recharge.

Shading the means by which an artist represents gradations of tone.

Vanishing point the place in a perspective drawing where parallel lines appear to converge.

Warm colours reds, yellows and oranges. They are associated with fire and earth.

Watercolours paints made of pigments suspended in water. They come in tubes, blocks or bottles.

Watercolour wash a layer of diluted watercolour painted across the paper.

Water-soluble crayons used to draw. Water painted over the drawing disperses the pigment and turns it into a watercolour wash.

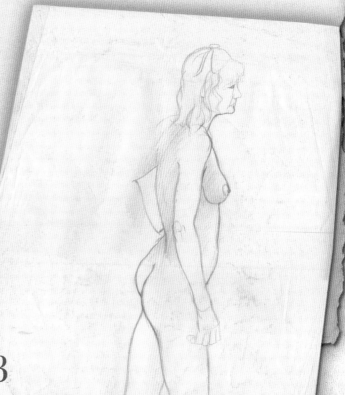

Index

3D 8, 18, 26, 32, 34, 36, 45, 62

A
anatomy 10-13, 29, 34, 62
artist's mannequin 10, 35, 62

B
ballpoint pen 20, 28, 40
bleed 56, 57, 62
blending technique 50
blocking-in 9, 51, 62

C
cartridge paper 7, 46, 56, 58
charcoal 6–9, 19, 28, 42–45, 60, 61
chiaroscuro 32, 62
colour temperature 54
construction lines 16-18, 25, 62
conté crayon 28, 33, 48, 49, 62
contour shading 45, 51, 52
cross-hatching 32, 52, 62

F
face 16, 30
features 16, 17, 34
feet 20, 21
foreshortening 24, 25, 62

G
geometric shapes 18, 22
geometricising 22, 23, 62
graphite pencil 6, 8, 9, 28, 32, 44, 50, 59

H
hands 18, 19, 23, 30
hatching 32, 45, 51, 52, 62
heads 14–17, 23, 29, 30

I
ink 7–9, 28, 46, 47, 52, 53, 55, 60

L
large scale 50, 58, 59
light source 4, 32-35, 63
limited palette 7, 57

M
mixed media 60, 63
muscle 10, 12, 13, 33–35

N
negative space 38, 39, 63

P
pastel 7, 25, 28, 44, 48-51, 54, 55, 61, 62
pencil crayon 5, 7, 33, 41, 50, 55

perspective
perspective 26, 27, 36, 62, 63
photographs 34
proportion 14, 15, 29, 35, 38, 62, 63
putty eraser 6, 28, 44

R
Rodin, Auguste 60, 62

S
scratch pen 7, 8, 28, 52, 63
scribbling 21, 32
shading 7, 16, 18, 20, 24, 32–36, 39, 42, 44, 45, 48, 51, 52, 56, 58, 59, 62, 63
silhouette 38
skeleton 10, 11, 62
sketchbook 4, 28, 37, 40
smudge/smudging 9, 32, 43, 45, 62

T
tonal contrast 47, 56

V
vanishing point 26, 27, 63

W
wash 46, 56–59, 63
watercolour 7, 9, 46, 55-58–61, 63